ANDREW STEVOVICH

Petals on a Bough

Exhibition Continues:

Clark Gallery

Lincoln, MA
November 7 - 29, 2007

Front and Back cover : *In the Garden,* 2005-2007 (detail). Page 13 - 14

ANDREW STEVOVICH

Petals on a Bough

OCTOBER 2 - NOVEMBER 3, 2007

 ADELSON GALLERIES

19 East 82nd Street New York, NY 10028

Telephone (212) 439-6800 www.adelsongalleries.com

To Dr. Bernard Cohen
a great friend and
a great collector

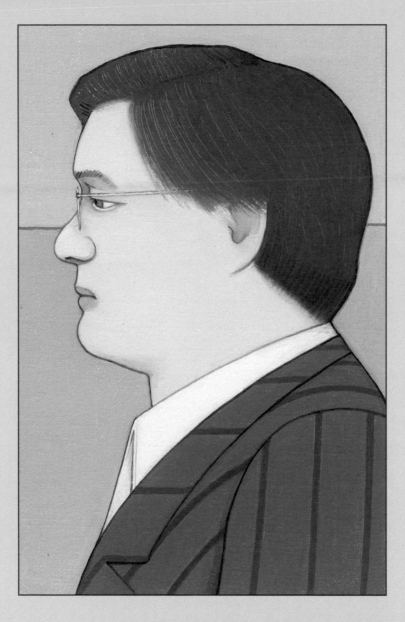

Portrait: Warren, 2006
Oil on linen, 6 x 4 $^{1/4}$ inches
(Private Collection)

Petals on a Bough

L AST YEAR Andrew Stevovich gave me a present. It was portrait of me, and he extended his hand to tell me that it was in celebration of our twenty-fifth year. I was moved by the gift, unexpected and generous. It is reproduced herein and is typical of Andrew's work, small in scale, a profile painted with his flat, polished surface and crisp, wiry line. I looked at it and saw myself. I looked at it and saw Andrew as well. The twenty-five years were more difficult to see.

Andrew was introduced to me by a man that was my first client, Dr. Bernard Cohen of Gloucester, Mass. When I opened my gallery in the mid 1960's in Boston, Bernie was literally the first person to buy a painting from Adelson Gallery, and over the years became a supportive and constant friend. It was he that suggested I look at Andrew's work years ago, and I was an instant convert to these unusual and original canvases. We have done many exhibitions together, and I have collected many of his paintings over these years personally. I look at them every day at home and his canvases never lose interest or mystery. I love his work and relish seeing the array of characters on my wall that greet me with their lives and emotions.

Andrew's style is not easy to describe: he fits in no artistic pigeonhole. I relate his work to all sorts of other art, from the 15th century to the present, and yet he really looks like no other painter. His subjects are familiar, seeming to be drawn from his life and his surroundings, but the iconography of his pictures is invariably elusive. It always seems something obvious is happening, but the mood, the feeling is usually alien to the event. That is the edge in Andrew's work: it is the surprise in the emotion that you feel.

John Sacret Young, the writer and director, has written about Andrew in the recently published *Andrew Stevovich: Essential Elements* (Hard Press Editions, 2007). "Here is an artist who sets the table, puts into play with remarkable polish the situations and players of his unique dreamscapes. We find ourselves at a carnival, a nightclub, a racetrack, a card game, a movie theater, a coffeehouse, or we come upon a woman alone with a butterfly, a tulip, a cat, or a drink. We arrive at some unknown chapter in their stories as witnesses, if not voyeurs, and are tugged upon to join these specimens in their strangely sealed worlds."

I have looked at old family photographs and had similar emotions. In my library at home is a framed snapshot of my mother and father standing on a dock by a lake. Harry wears a white sweater and striped pants and holds an oar of the rowboat behind them in the water. Beaze is in high-waisted shorts and a sleeveless top, and links her arm in his. They are very young and their smiles are pure. She called it their wedding photograph; it is inscribed in her hand, "Maine 1934." It was taken seventy years ago, but to me it could be seven hundred; they seem so remote in their period outfits and unfamiliar youthfulness. And yet they project their feelings to me in this small snapshot taken so long ago, and I conjure all the emotions of my days with them. That is Andrew Stevovich's natural gift. It is his ability to glimpse a small moment and make us see its ardor, its powerful emotion. John Sacret Young calls those moments "petals on a bough." I like that. There are many petals in this exhibition.

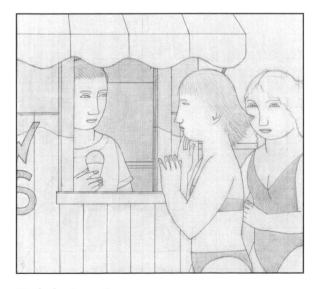

Study for Snow Cone, 2004
Pencil on paper with pastel tone on reverse
11 x 12 inches

Warren Adelson
July 2007

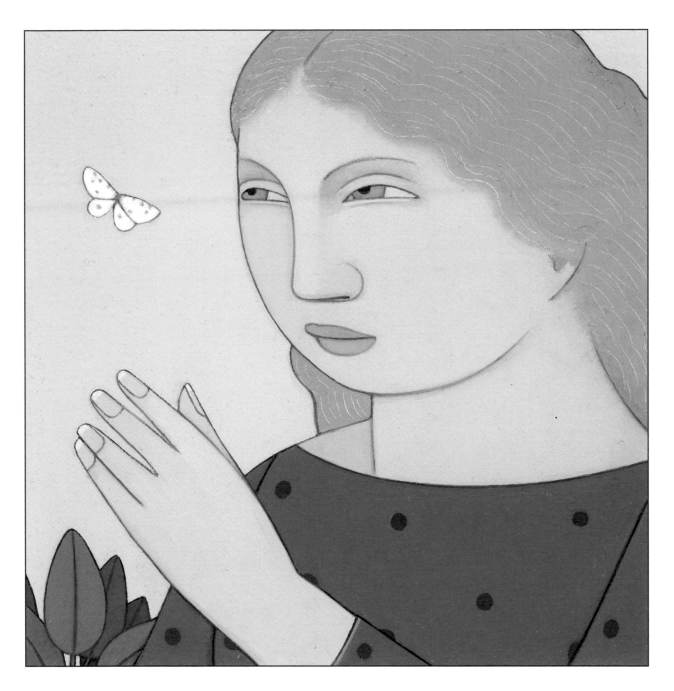

Woman with Butterfly, 2005
Oil on linen, 5 ¼ x 5 ¼ inches

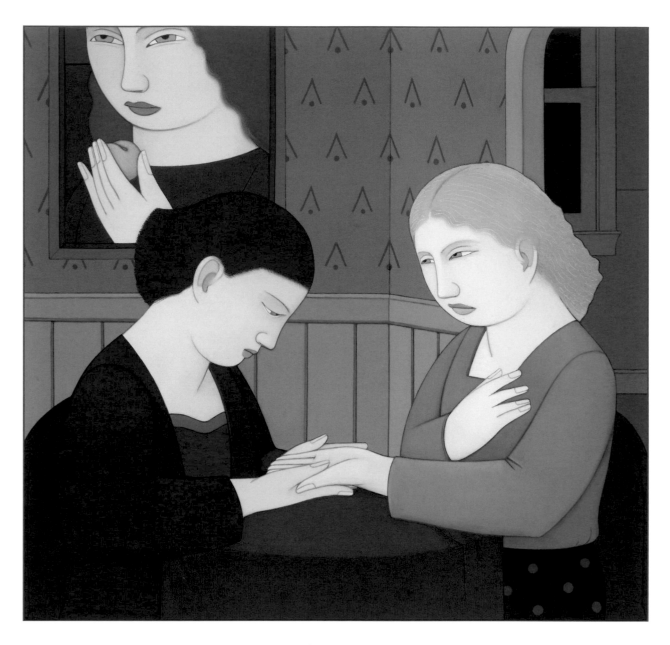

Palm Reader, 2006
Oil on linen, 11 x 12 inches

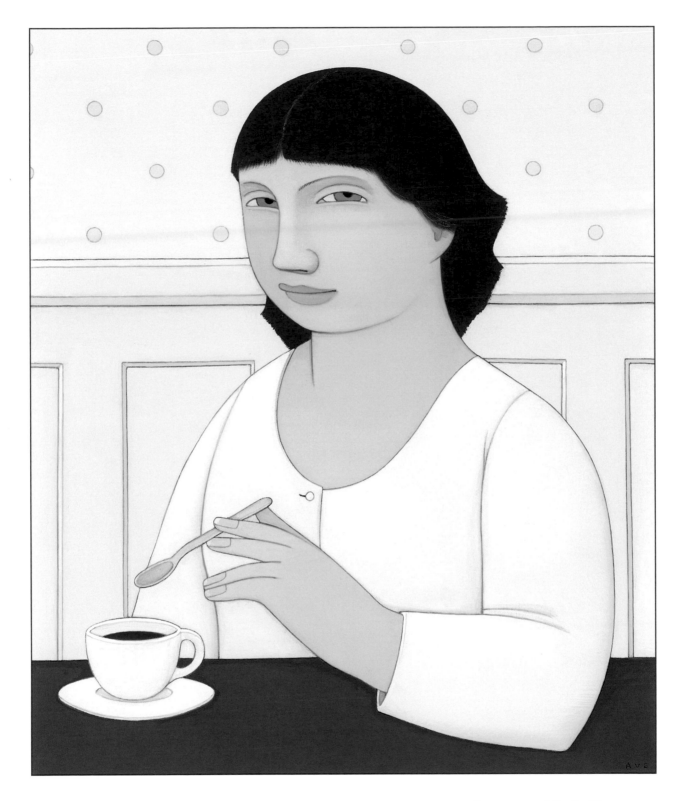

Loretta with Coffee, 2004
Oil on linen, 12 x 10 inches

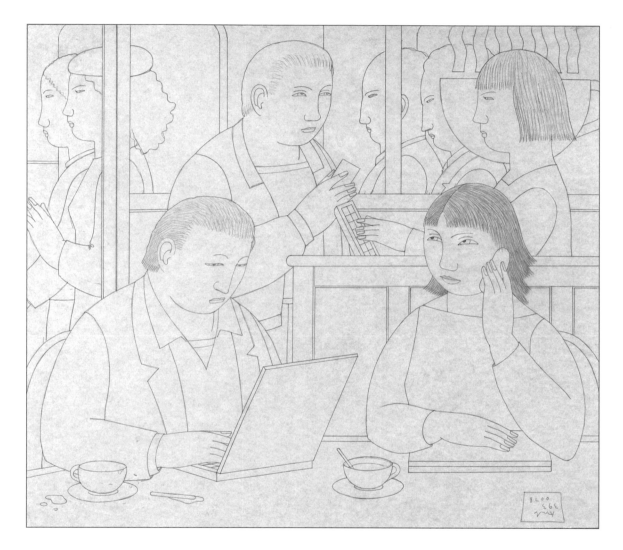

Study for Internet Café, 2006
Pencil on paper with pastel tone on reverse, 28 x 32 inches

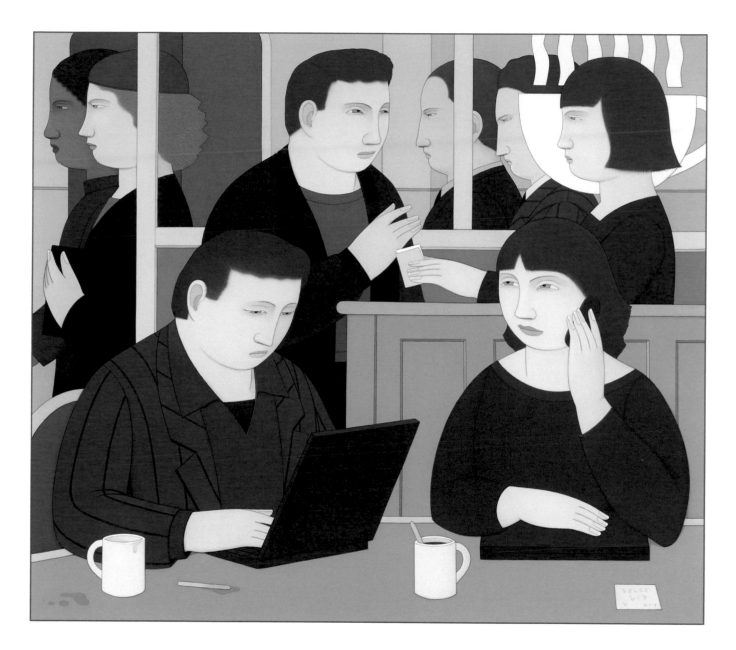

Internet Café, 2006
Oil on linen, 28 x 32 inches

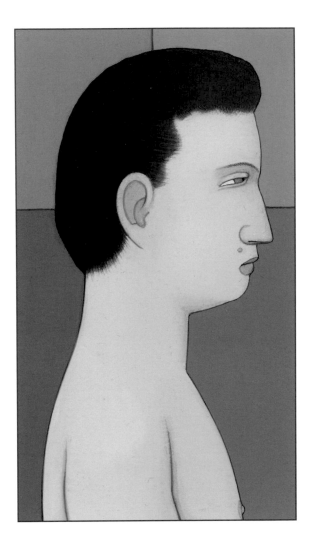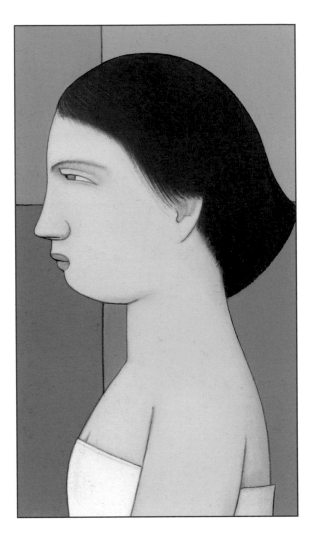

Couple in Pink, 2006
Oil on linen, diptych, 6 $^{5/8}$ x 9 $^{1/2}$ inches (overall)

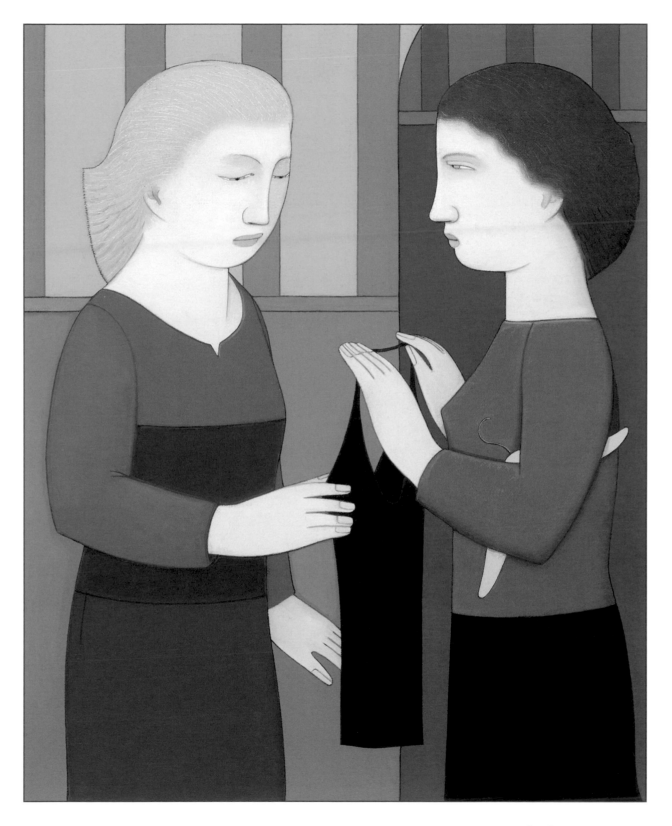

Black Dress, 2004
Oil on linen, 10 x 8 ¹/₈ inches
(Private Collection)

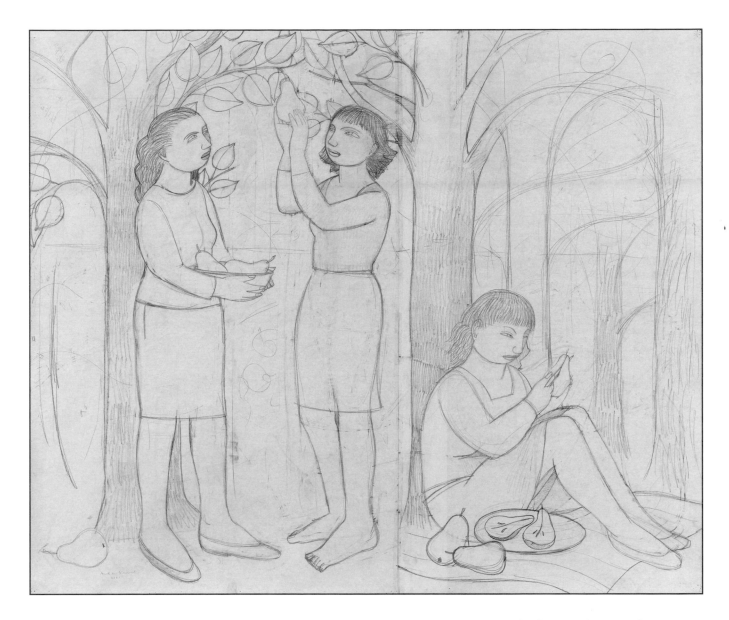

Study for In the Garden, 2001
Pencil and pastel on paper, 62 x 72 inches

In the Garden, 2005-07
Oil on linen, 62 x 72 inches
(Collection of Edwin and Maryann Roos)

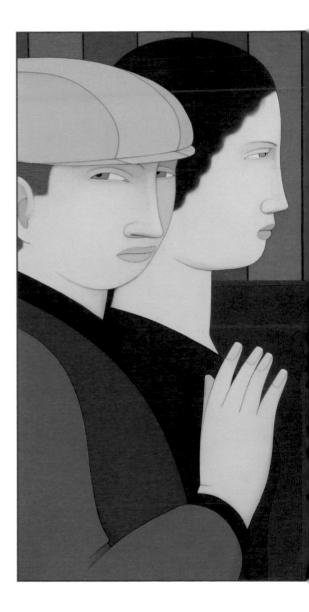

Lola, 2005
Oil on linen, triptych, 20 x 41 $^{1/2}$ inches (overall)

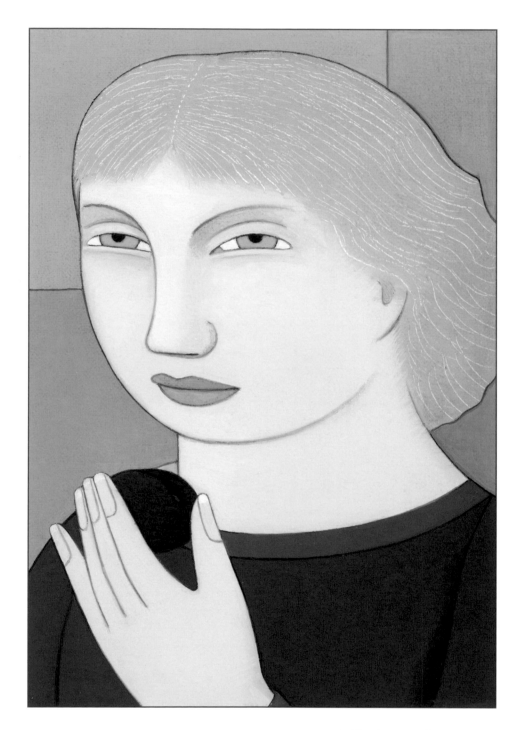

Woman Offering a Plum, 2006
Oil on linen, 6 3/8 x 4 3/4 inches
(Private Collection)

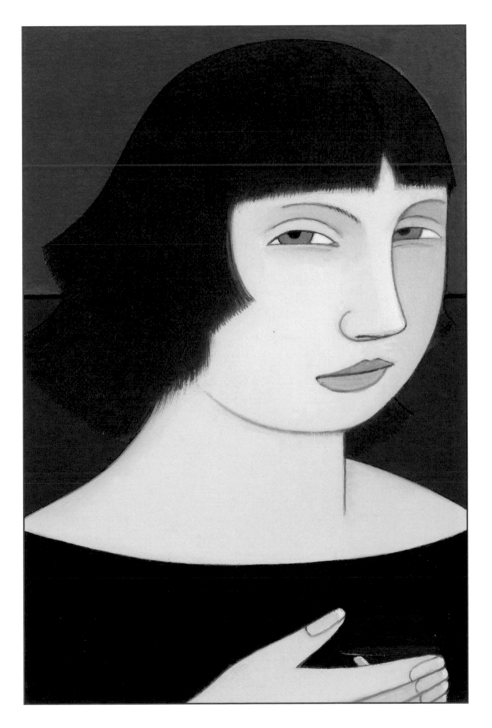

Loretta with Martini, 2005
Oil on linen, 5 $^{3/4}$ x 4 $^{1/8}$ inches
(Private Collection)

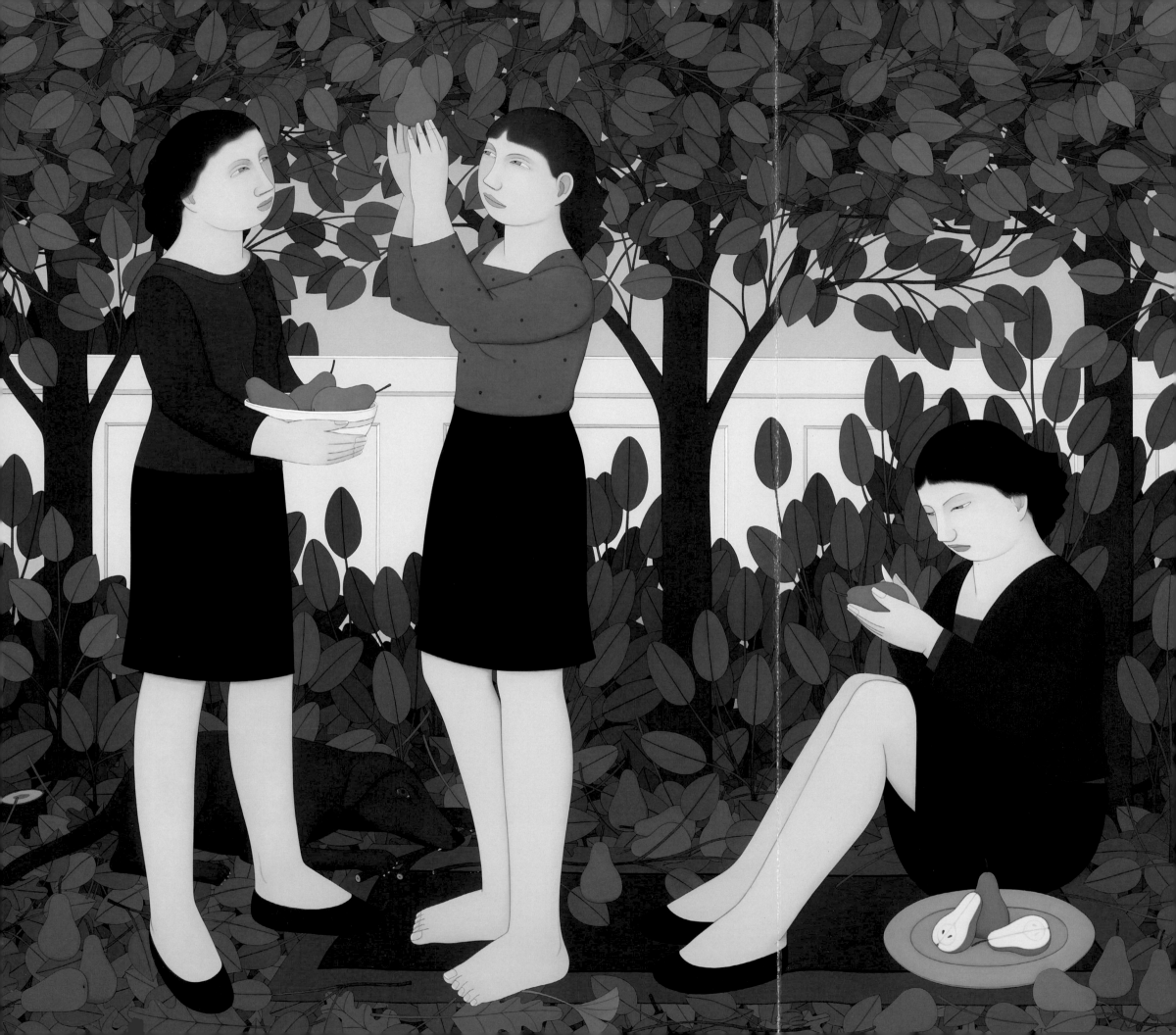

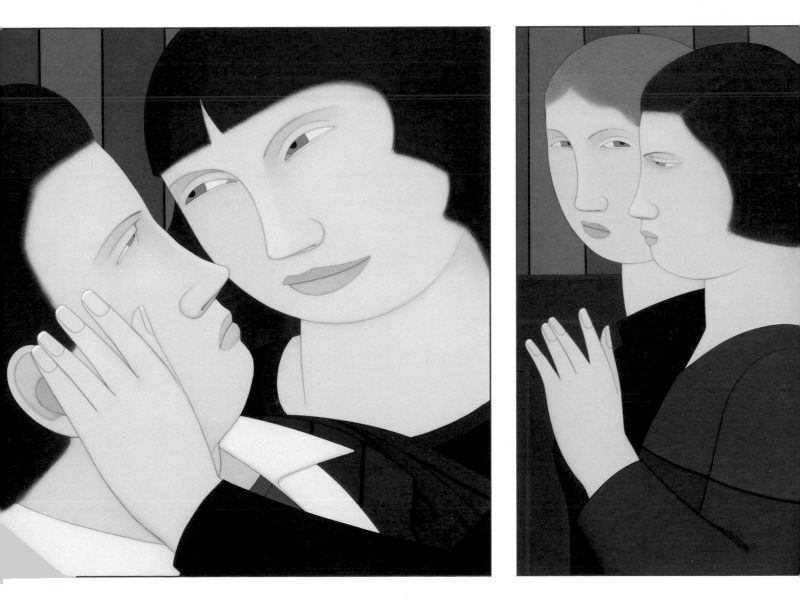

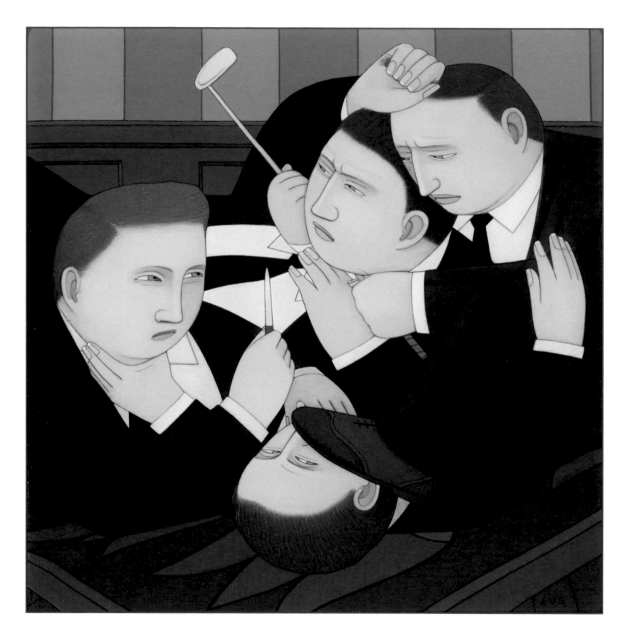

Four Men Fighting, 2005
Oil on linen, 10 x 10 inches

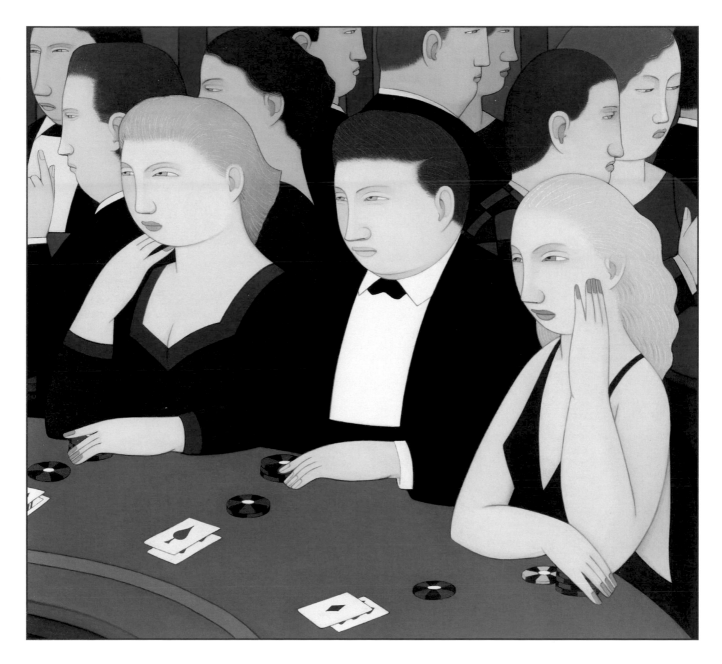

Casino, 2005
Oil on linen, 11 x 12 inches
(Collection of Daniel Greenblatt)

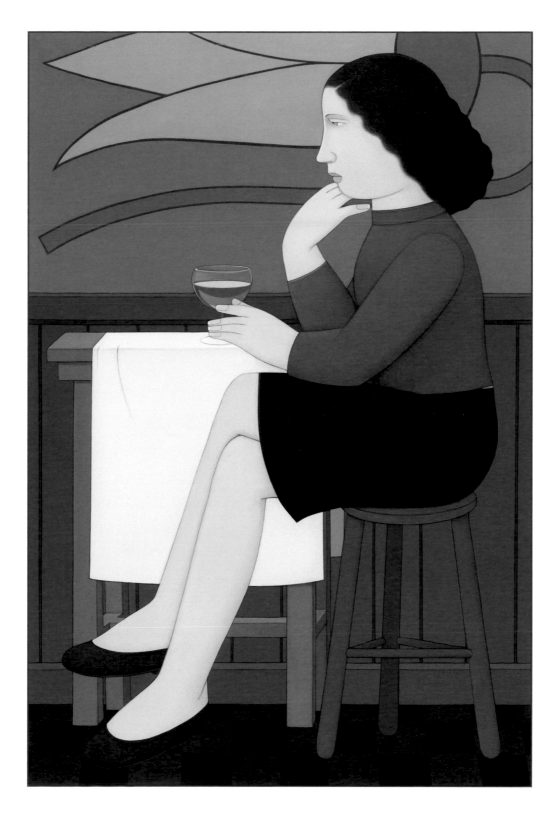

Woman Drinking at the Blue Lotus, 2004
Oil on linen, 24 x 16 inches

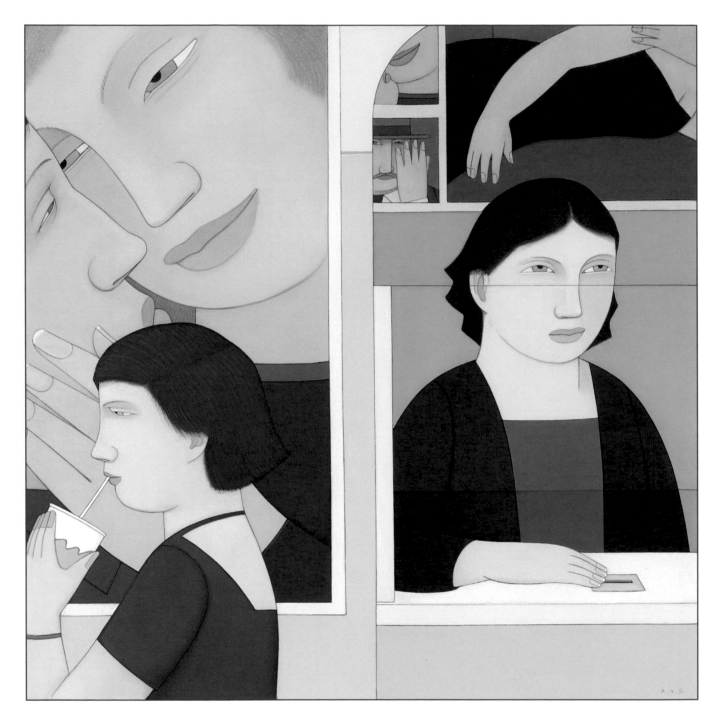

Movie Lobby, 2005
Oil on linen, 15 x 15 inches

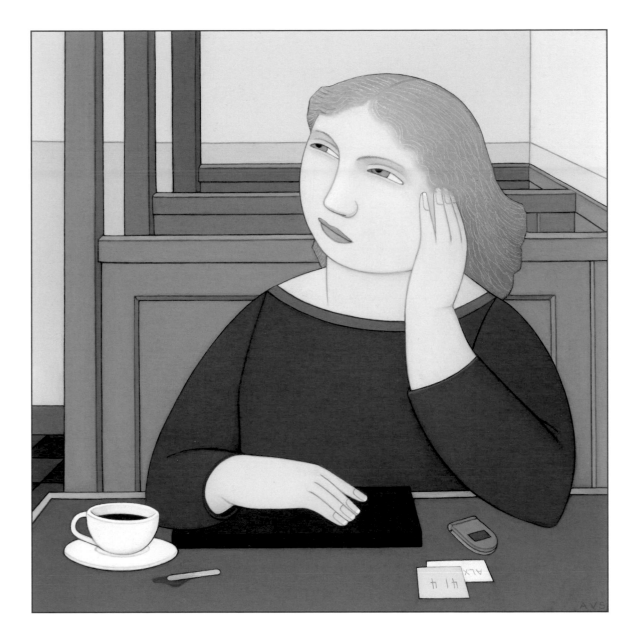

Woman in Booth with Laptop, 2006
Oil on linen, 10 ¹/₈ x 10 ¹/₈ inches

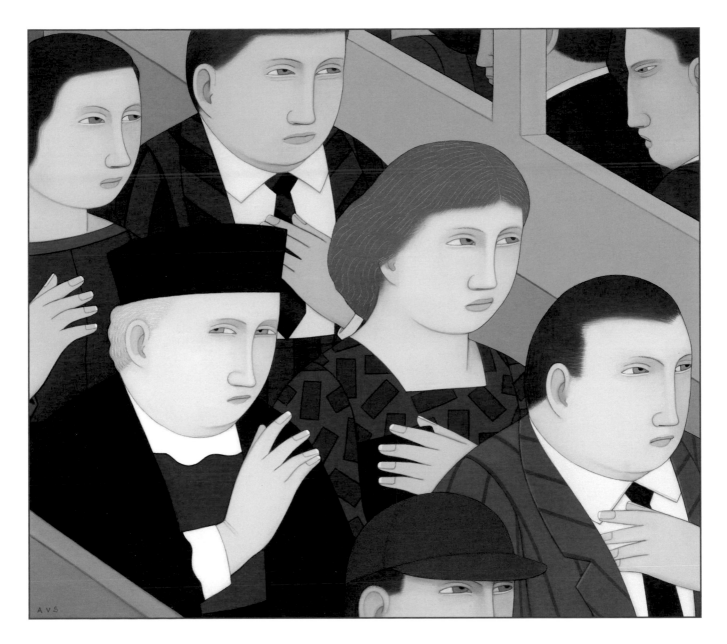

Subway Stairs, 2004
Oil on linen, 13 ⁵/₈ x 15 ⁵/₈ inches

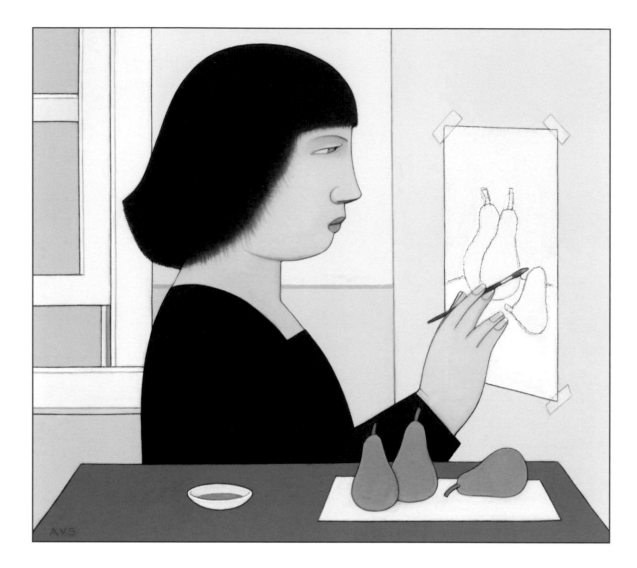

Woman About to Paint Pears, 2005
Oil on linen, 7 ¹/₄ x 8 ¹/₈ inches
(Private Collection)

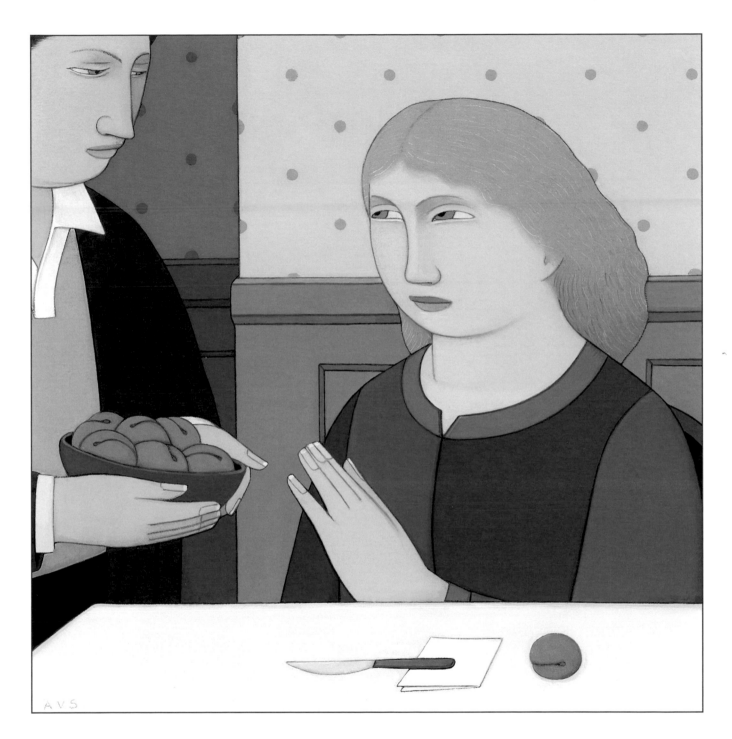

Couple with Apricots, 2004
Oil on linen, 9 x 9 inches

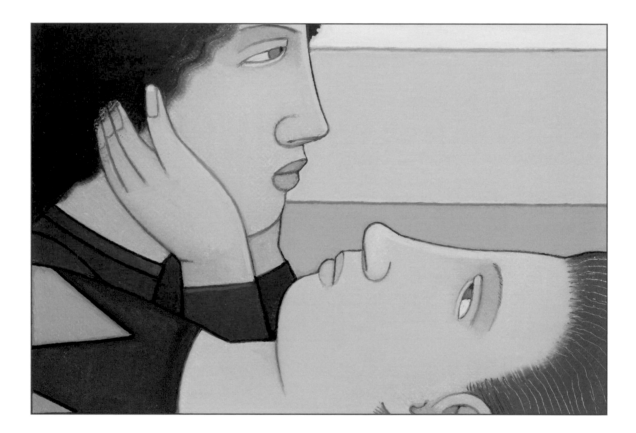

Couple by the Sea, 2005
Oil on linen, 3 $^{1/2}$ x 4 $^{3/4}$ inches

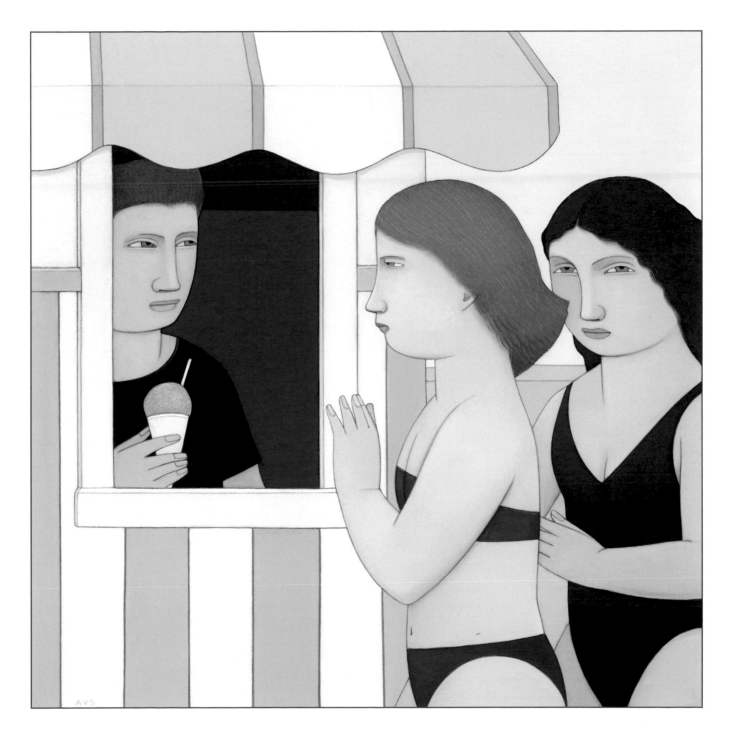

Snow Cone, 2004
Oil on linen, 12 x 12 inches
(Private Collection)

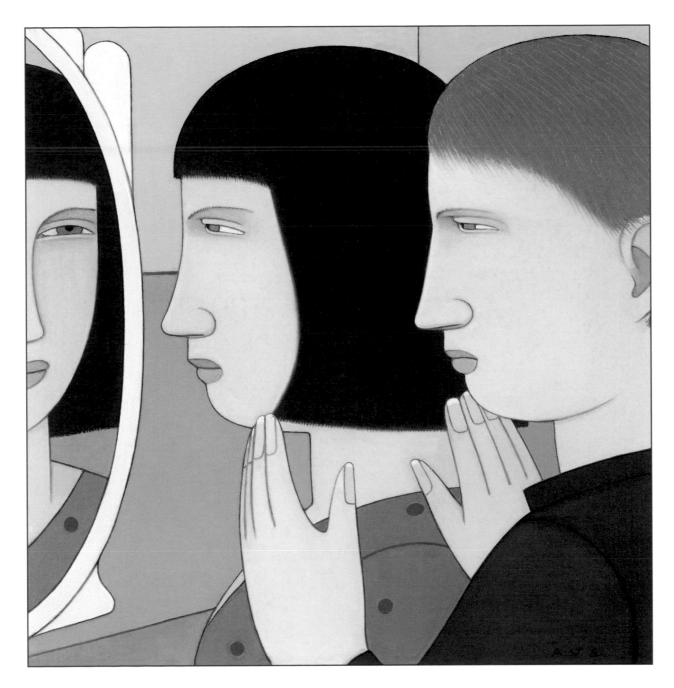

Beauty Parlor, 2005
Oil on linen, 7 ¹/₄ x 7 ¹/₄ inches
(Collection of Allison Cohen)

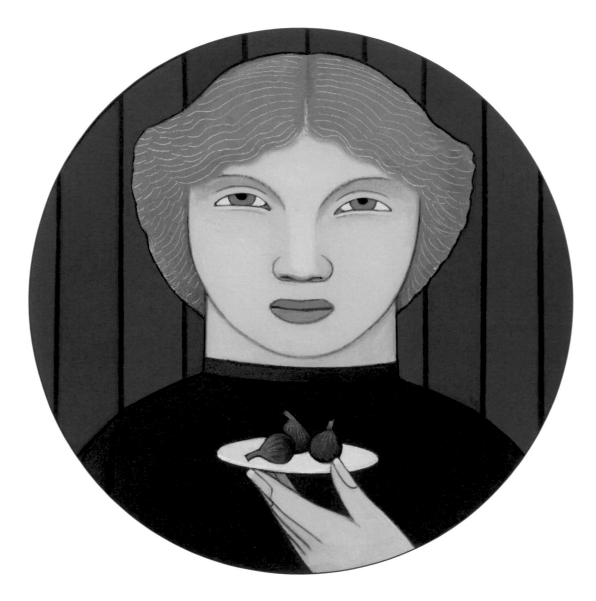

Woman with Figs, 2005
Oil on linen, 5 ¹/₄ inches diameter

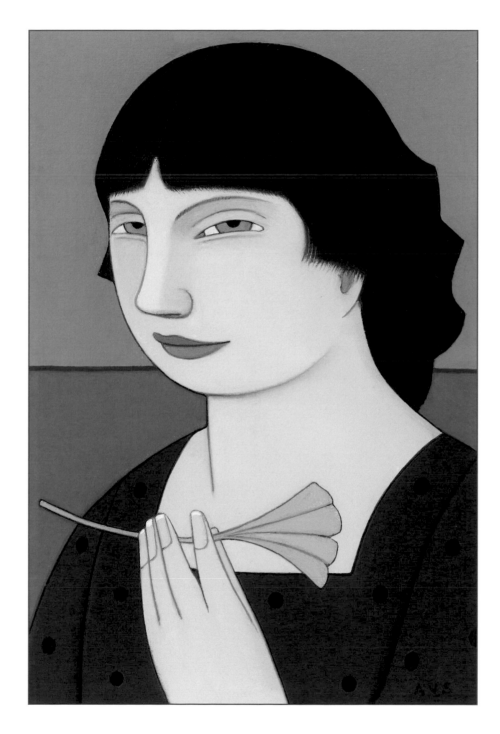

Ginko, 2007
Oil on linen, 6 x 4 inches

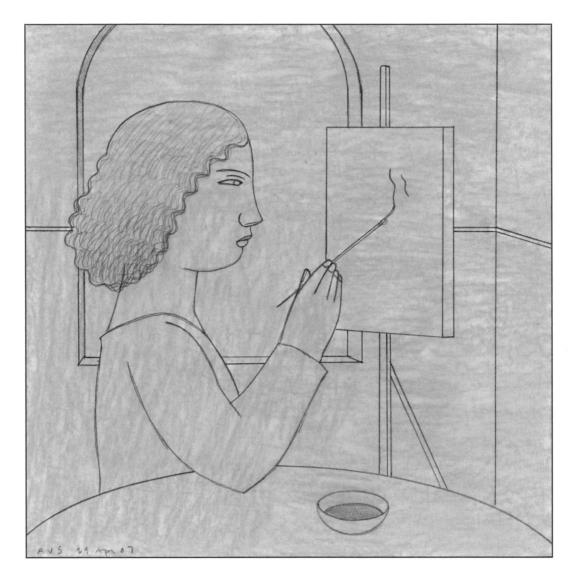

Study for Painting, 2007
Pencil on paper with pastel tone on reverse, 9 x 9 inches

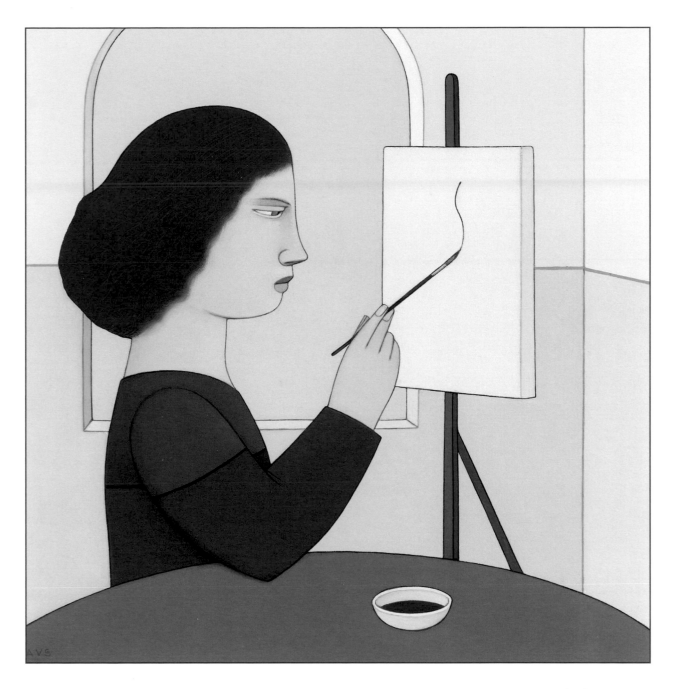

Painting, 2007
Oil on linen, 9 x 9 inches

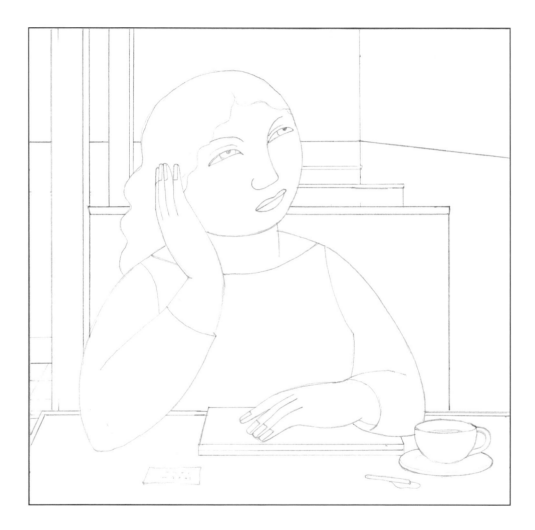

Study for Woman in Booth with Laptop, 2006
Pencil on paper, 8 x 8 inches

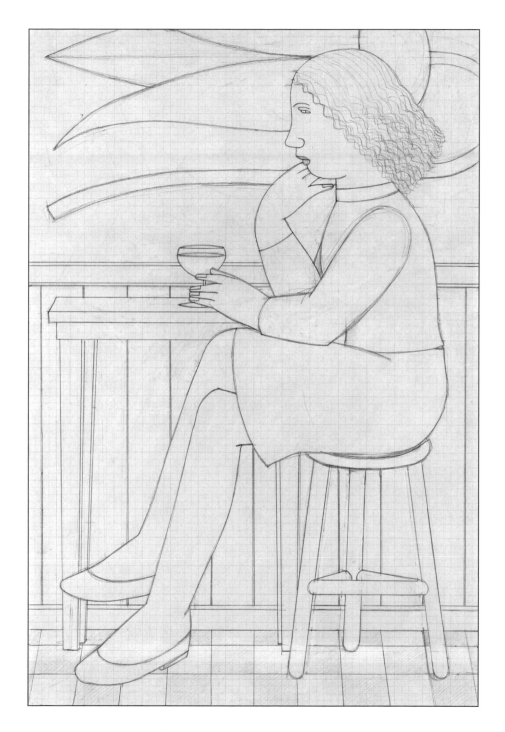

Study for Woman Drinking at the Blue Lotus, 2004
Pencil on paper with pastel on back, 24 x 16 inches

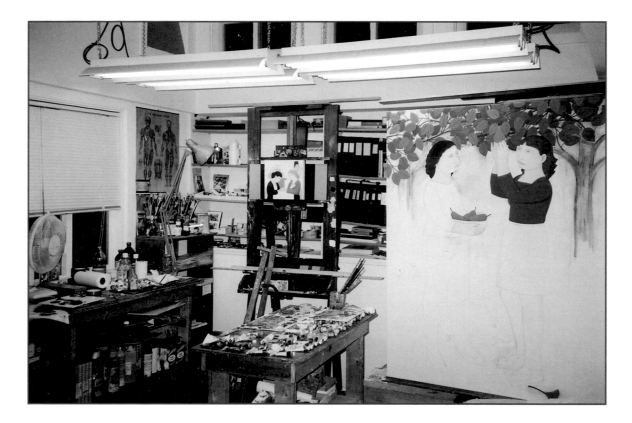

Artist's Studio, 2005

Andrew Stevovich

Born: July 2, 1948 (Salzburg, Austria)

Education: MFA: Painting, Massachusetts College of Art, 1980
 BFA: Painting, Rhode Island School of Design, 1970

Selected Solo Exhibitions:
Adelson Galleries, Inc., New York, 1992, 1995, 1999, 2001, 2004
Alpha Gallery, Boston, 1971, 1973, 1976, 1978
Clark Gallery, Lincoln, Massachusetts, 1985, 1990, 1997, 1999, 2004
Clark University, Worcester, Massachusetts, 1980
Coe Kerr Gallery, New York, 1983, 1985, 1987, 1990
Danforth Museum of Art, Framingham, Massachusetts, 1999
David Brown Gallery, Provincetown, Massachusetts, 1987
Impressions Gallery, Boston, 1982
The Loft Gallery, Huntsville, Alabama, 1999
Mast Cove Galleries, Kennebunkport, Maine, 1990
Mitsukoshi Gallery, Ebisu, Tokyo, 1996
New Britain Museum of American Art, New Britain, Connecticut, 1975
Pisa Galleries, Tokyo, Japan, 1992
Tatistcheff Gallery, Santa Monica, California, 1989, 1993
Terrence Rogers Fine Art, Santa Monica, California, 2000
Virginia Lynch Gallery, Tiverton, Rhode Island, 1992

Selected Group Exhibitions:
Approaches to Narrative, DeCordova Museum, Lincoln, MA, 2007
Annual Salon Show, Clark Gallery, 1993, 1994, 1995, 1996, 1997, 1998, 1999, 2000, 2001, 2002, 2003, 2004, 2005, 2006
New Acquisitions, DeCordova Museum, Lincoln, Massachusetts, 2003
Treasure, Terrence Rogers Fine Art, Santa Monica, California, 2002
Virginia Lynch: A Curatorial Retrospective, Rhode Island Foundation, Providence, Rhode Island, 2000
Figurative Works of Art, Virginia Lynch Gallery, Tiverton, Rhode Island, 2000
Twenty Prints from Fifty Boston Years: 1949-1999 (Collection of the Boston Public Library), MPG, Boston, Massachusetts, 1999
The Cutting Edge: A Short History of the Woodcut, Portland Museum of Art, Maine, 1995
Self-aMUSEd: The Contemporary Artist as Observer & Observed, Fitchburg Art Museum, Fitchburg, Massachusetts, 1993
Group Exhibition, Tatistcheff-Rodgers Gallery, Santa Monica, 1991
Recent Acquisitions, Portland Museum of Art, 1991
Group Exhibit, Virginia Lynch Gallery, 1991, 1993
Contemporary Paintings, Coe Kerr Gallery, 1990
The Art of Love, Riverside Art Museum, Riverside, California, 1990 Common Roots/Diverse Objectives: Rhode Island School of Design Alumni in Boston, Fuller Art Museum, Brockton, Massachusetts, 1989
The Art Show, New York, 1989
Art/L.A., Los Angeles, 1989
The Art of Printmaking, Fitchburg Art Museum, Massachusetts, 1988, and the Galerie Kunst in Turm, Kleve, Germany, 1989
Modern Works on Paper, Fergus-Jean Gallery, Columbus, Ohio, 1988
20th Century American Realism from the Blum Collection, Aetna Art Institute Gallery, Hartford, Connecticut, 1988
The Art of Printmaking, Fitchburg Art Museum, Massachusetts, 1988, and the Galerie Kunst in Turm, Kleve, Germany, 1989
Modern Works on Paper, Fergus-Jean Gallery, Columbus, Ohio, 1988

20th Century American Realism from the Blum Collection, Aetna Art Institute Gallery, Hartford, Connecticut, 1988
Chicago International Art Exposition, Chicago, Illinois, 1988, 1987, 1985, 1984
Contemporary Paintings, Community Gallery, Lancaster, Pennsylvania, 1986
Modern and Contemporary Paintings, Coe Kerr Gallery, 1984
Bathers, Coe Kerr Gallery, 1984
Contemporary Paintings, Gallery of Lancaster, Pennsylvania, 1984
Realistic Directions, Zoller Gallery, Pennsylvania State University, 1983
Andrew Stevovich and Shirl Goedike, Fine Arts America Gallery, Richmond, Virginia, 1983
4 Printmaking, Knott Gallery, Bradford College, Massachusetts, 1983
American Realism, Coe Kerr Gallery, 1983
20th Century American Art, Coe Kerr Gallery, 1982
Stone & Steel: Boston Printmakers, Heritage Plantation, Sandwich, Massachusetts, 1982
American Realism, Coe Kerr Gallery, 1982
20th Anniversary Exhibition, Corcoran Gallery of Art, Washington, DC 1981
Boston Artists' Work on Paper, Boston University Gallery, Massachusetts, 1981
Collector's Choice, Newton Art Center, Massachusetts, 1981
Brockton Triennial, Fuller Art Museum, 1978
New Talent, Marilyn Pearl Gallery, New York, 1977
Patron's Choice, DeCordova Museum, Lincoln, Massachusetts, 1976
Arita / Reichert / Stevovich, Woods-Gerry Art Gallery, Rhode Island School of Design, Providence, Rhode Island, 1970
Home on the Range (West by East), Woods-Gerry Gallery, Rhode Island School of Design, 1970
New Talent, Alpha Gallery, 1970
Open Painting, Providence Art Club, Providence, Rhode Island, 1970, 1969

Public Collections:
Addison Gallery of American Art, Andover, Massachusetts
Boston Athenaeum
Boston Public Library
Corcoran Gallery of Art, Washington DC
Danforth Museum, Framingham, Massachusetts
DeCordova Museum, Lincoln, Massachusetts
Estonian Art Museum (Eesti Kuntstimuuseumi), Tallin, Estonia
Fuller Art Museum, Brockton, Massachusetts
Museum of Fine Arts, Boston
New Britain Museum of American Art, New Britain, Connecticut
Portland Museum of Art, Portland, Maine

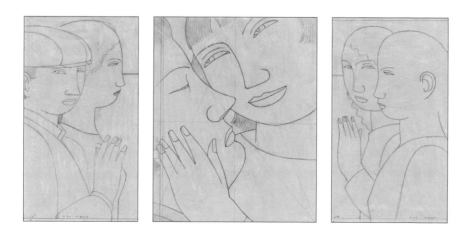

Study for Lola, 2005
Pencil on paper with pastel on back, triptych, 20 x 41 inches (overall)

ISBN : 978-0-9741621-6-4

Design: Todd Masters

Photography: John Bigelow Taylor

Printing: GHP

Thanks to Caroline Owens Crawford for her efforts on this exhibition and to Lisa Bush Hankin for editing the catalogue.